CONTENTS

POCKET GUIDES
STILL LIFE

Erika Langmuir

L'EMDN
ANO 1772.

NATIONAL GALLERY COMPANY LONDON

DISTRIBUTED BY YALE UNIVERSITY PRESS

THE POCKET GUIDE SERIES

Allegory, Erika Langmuir

Angels, Erika Langmuir

Colour, David Bomford and Ashok Roy

Conservation of Paintings, David Bomford

Faces, Alexander Sturgis

Flowers and Fruit, Celia Fisher

Frames, Nicholas Penny

Impressionism, Kathleen Adler

Landscape, Erika Langmuir

Saints, Erika Langmuir

Front cover and title page:
Luis Meléndez, *Still Life with Oranges and Walnuts*, 1772, 61 x 81.3 cm.

Frontispiece:
William van Mieris, *A Woman and a Fish-Pedlar in a Kitchen*, 1713, detail.

First published in Great Britain in 2001 by
National Gallery Company Limited
St Vincent House, 30 Orange Street, London WC2H 7HH
www.nationalgallery.co.uk

ISBN 1 85709 961 3

525234

British Library Cataloguing-in-Publication data.
A catalogue record is available from the British Library.
Library of Congress Catalog Card Number: 20-01095567

Edited by Jan Green
Designed by Gillian Greenwood
Printed and bound in Germany by
Passavia Druckservice GmbH, Passau

FOREWORD

The National Gallery contains one of the finest collections of European paintings in the world. Open every day free of charge, it is visited each year by millions of people.

We hang the Collection by date, to allow those visitors an experience which is virtually unique: they can walk through the story of Western painting as it developed across the whole of Europe from the beginning of the Renaissance to the end of the nineteenth century – from Giotto to Cézanne – and their walk will be mostly among masterpieces.

But if that is a story only the National Gallery can tell, it is by no means the only story. The purpose of this series of *Pocket Guides* is to explore some of the others – to re-hang the Collection, so to speak, and to allow the reader to take it home in a number of different shapes, and to follow different narratives and themes.

Still life, the most domestic and familiar of pictorial genres, is disclosed as unexpectedly complex. Christian saints, and the angels who flit through so many of the earlier works in the Gallery, shed light not only on the meaning of individual pictures but also on the functions of religious art in European society. Colour, that fundamental ingredient of painting, is shown to have a history, both theoretical and physical – and Impressionism, perhaps the most famous episode in that history, is revealed to have been less a unified movement than a willingness to experiment with modern materials and novel subject matter.

These are the kind of subjects and questions the *Pocket Guides* address. The pleasures of pictures are inexhaustible, and our hope is that these little books point their readers towards new ones, prompt them to come to the Gallery again and again and accompany them on further voyages of discovery.

Neil MacGregor
DIRECTOR

INTRODUCTION

It is easy to see why so many people find Henri Fantin-Latour's *The Rosy Wealth of June* [1] attractive, and enjoy owning similar pictures. Who wouldn't be glad of such a splendid bouquet, especially if the flowers didn't make you sneeze, and – tokens of summer for all seasons – retained their fragile beauty indefinitely?

The great popularity of floral images has made them so familiar that we tend to look *through* them to the things they represent. We almost forget that pictures like Fantin's are not spontaneous creations, but complex artefacts indebted to a centuries-old tradition of Western painting.

Clay flowerpots, on the other hand, would barely merit a second glance on a terrace, yet it is precisely their presence in the foreground that makes Laurent de La Hyre's *Allegorical Figure of Grammar* memorable [2]. And if, instead of roses, delphiniums, begonias and flowerpots, we think of ... cabbages, the mysterious nature of this painting tradition becomes all the more apparent. At the greengrocer's, cabbages are just vegetables. They're even associated with dullness and a lack of wit (nobody wants to become one). Why, then, should the semblance of two gigantic green cabbages in a work of art seem so exhilarating – and why should a painter wish to represent them in the first place [frontispiece, 3,7]?

Flowers, fruit, vegetables and other foodstuffs, pots and pans, tableware, books, musical instruments – in short, objects of all kinds – are the typical subject matter of still-life painting. Sometimes they are beautiful, ornate and desirable in themselves; very often they are commonplace household items. It is their re-presentation in paint that makes them seem remarkable, and a source of special enjoyment.

The purpose of this short *Guide* is to enrich that enjoyment by exploring the nature and history of still-life painting. The subject is more complex than it seems. It goes to the very heart of the relationship between art and reality, perception and representation, and touches on how artists view their role in

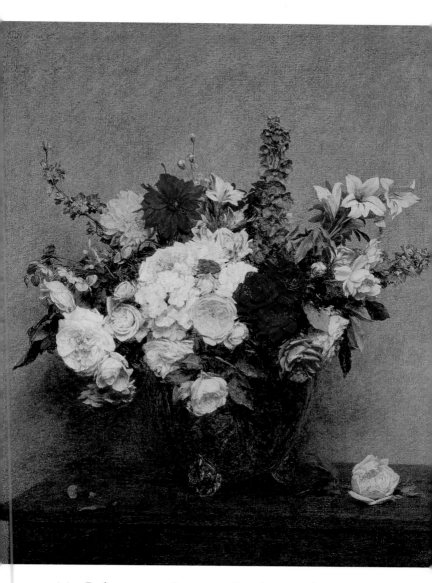

society. Perhaps more than any other topic in the visual arts, it also requires definition: virtually everybody knows what kinds of things are represented *in* still life, but has difficulty explaining precisely what still life *is*.

Of the three images reproduced in Figures 1, 2 and 7, only Fantin-Latour's flower piece [1] can properly be called 'a still life'. The term – a latecomer in European languages – denotes a particular genre, or category, of picture, analogous to other familiar types such as portraiture or landscape. Known in ancient

1. Ignace-Henri-Théodore Fantin-Latour, *The Rosy Wealth of June*, 1886. 70.5 x 61.6 cm.

Greece and Rome, still life was revived around 1600, and became a focus of artistic experiment from the late nineteenth century to our own time.

But no exploration of still life can overlook pictures in other genres – such as La Hyre's *Allegorical Figure of Grammar* [2] – that prominently feature still-life motifs. Grammar is, of course, not a real person but an abstract notion, one of the Seven Liberal Arts in the curriculum of higher education dating from pagan antiquity. Her pedigree is reflected in the painting's solemn geometry, the Latin inscription wound about the figure's arm, and her resemblance to a classical statue, surrounded by fragments of ancient Roman architecture. Instead of showing the personification of Grammar with her medieval attribute, a schoolmaster's cruel whip, La Hyre chose to illustrate her kindlier aspect, as described in a French edition of Cesare Ripa's *Iconologia*, a popular artist's handbook first published in 1593: 'Like young plants, young brains need watering and it is the duty of Grammar to undertake this.' Having assembled suitable objects – a battered kitchen jug, frail

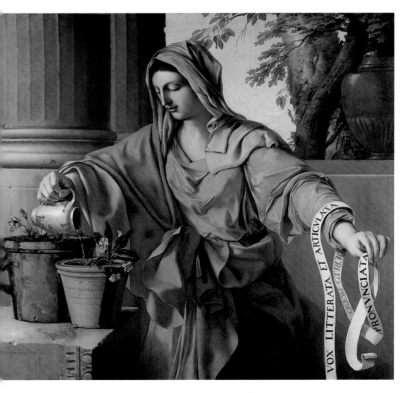

8

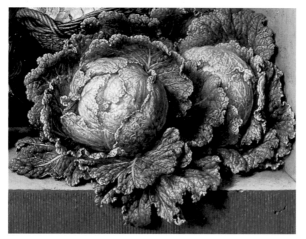

anemones and primulas newly planted in terracotta pots – he re-presented them as Grammar's emblems, at the same time reproducing every detail of their real-life appearance, down to the water trickling out of a drainage hole [4]. It is this realism, contrasting with the blander treatment of the personification, which draws and holds our gaze.

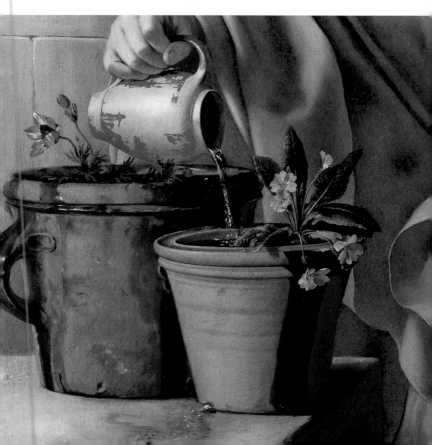

La Hyre's realistic garden pots were indebted to the contemporary vogue for still life. His use of real objects as symbols of abstract ideas, however, was a well-worn convention that had itself paved the way for the revival of pure still life around the time he was born. We find it, for example, in Duccio's painting of *The Annunciation* [5], part of an altarpiece installed in Siena Cathedral in 1311. The Archangel Gabriel appears in the Virgin Mary's chamber to announce the miraculous conception of her son, Jesus. Nothing distracts from the drama – except a prominently displayed vase of white lilies between the two protagonists. To those familiar with Christian imagery, however, the vase and its flowers are integral to the scene. They symbolise the Virgin Mary, addressed by the angel as 'full of grace'. She is the vessel of the Incarnation, in which God will be made flesh. She is

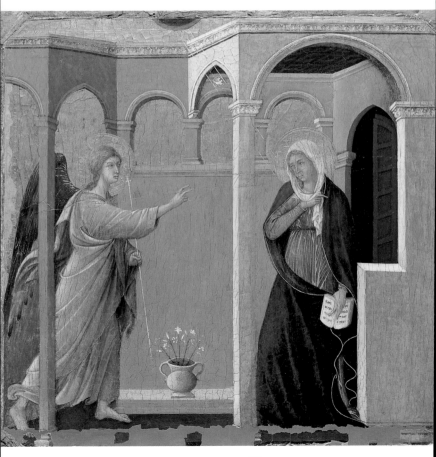

as pure as the white lilies. Since the lily or fleur-de-lis is a heraldic emblem of royalty, the flowers also allude to her as Queen of Heaven.

Like the popular preachers of his time, Duccio sought to persuade his audience not only of the spiritual relevance of the Christian story but also of its literal truth. The gold-leaf background and the figures of angel and Virgin were largely dictated by artistic convention, but the architecture and accessories could be tweaked to conform more closely to viewers' experience of reality. A pattern of light and dark tones sufficed to suggest a three-dimensional setting, illuminated by sunshine – or divine radiance – originating somewhere beyond the upper left-hand corner of the panel. The illusion is most convincing in the self-contained detail of the vase, which a simple system of shading transforms from a flat decorative shape into a hollow, rounded form set on a horizontal surface [6].

11

The more familiar such symbols became, the more readily they could stand in for the persons and ideas they symbolised. Some of the earliest independent still lifes painted in Europe around 1600 were, as we shall see, emblems and attributes of the Virgin taken out of their overtly religious context [46, 48, pages 60–3]. By the mid-seventeenth century, a specialised form of emblematic still life, called *vanitas*, had become popular in both Catholic and Protestant circles. Representing worldly goods alongside symbols of mortality, these pictures were intended to recall viewers to their moral obligations – the duty to 'fear God and keep his commandments' – by reminding them of the brevity of human life and the futility of secular accomplishments [49, 50, pages 64–6].

There exists in addition a third type of image which depends almost wholly on still-life motifs without actually being pure still life. Such works, mainly originating in the Low Countries, are now usually categorised as scenes of contemporary life. Yet the picture that features our cabbages is obviously not a record of fact but a fiction made up out of factual elements [7]. No eighteenth-century Dutch household could have afforded an antique stone relief as a kitchen counter or window sill, or such an ample supply of fish and game. The main *raison d'être* of pictures of this kind was not to depict real life, but to show off the artist's ability to reproduce the widest possible variety of surface textures. For this reason, still-life motifs are not limited to a few objects displayed in the foreground, but are dispersed throughout the painting. Crisp ruffled cabbages, a cat's and rabbits' soft fur, the plumage of different fowl, are contrasted with slippery cold fish and hard stone, earthenware, wicker baskets and a frayed rug. Peering into the background, we distinguish wood, china, pewter [8], even cured meat hanging from iron hooks. These everyday objects are included so that, knowing precisely what they feel like to the touch, the viewer can fully appreciate the virtuosity of the artist's brush. The contrast of multi-coloured 'life' – kitchen-maid, greedy cat and gnarled fish-pedlar – with 'art'– an antique stone sculpture of pagan marine gods and their fishy playmates – wittily demonstrates the superior representational skills of the modern Dutch painter. The narrative or anecdote implied by the

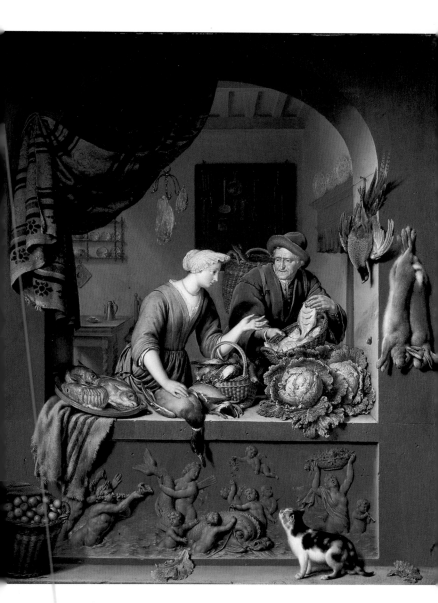

actions of the live figures is merely incidental.

These, then, are broadly the three kinds of pictures we will be discussing: independent realistic and/or emblematic still lifes; paintings of other genres with prominent, usually symbolic, still-life motifs, and images that rely on a multitude of still-life elements ostensibly to represent a 'slice of life'. I shall also be considering a kind of still-life painting, not illustrated in this Introduction, which falls uneasily somewhere between 'art' and ornament. Its main aim is to make

7. Willem van Mieris, *A Woman and a Fish-pedlar in a Kitchen*, 1713. 49.5 x 41 cm.

13

the viewer believe that inanimate objects are not represented but 'really there'. For this reason, it is called *trompe l'oeil*, 'deceiving the eye'.

It is useful for us now to make these distinctions, and perhaps inevitable in view of the way paintings are currently classified and exhibited. But it is equally important to recall that, until the nineteenth century, artists and viewers did not necessarily think of pictures so systematically. And while Duccio [5] indubitably lived before La Hyre [2] and Velázquez [28] preceded Cézanne [41], still-life painting in its many guises did not evolve tidily through different stages – which is one of the reasons why it is so devilishly difficult to write about.

THE ORIGINS
OF STILL LIFE

Antiquity

The earliest surviving still lifes in European art are ancient Graeco-Roman wall paintings representing fruit and other provisions, and sometimes including also live game, poultry and hunting dogs. They were called *xenia*, 'presents to a guest', from the Greek *xenos*, meaning either 'foreigner, foreign guest' or 'host'. Vitruvius, the Latin first-century BC writer on architecture and architectural decoration, explains how *xenia* received their name:

For when the Greeks became more luxurious ... they began to provide dining rooms, chambers and store-rooms of provisions for their guests from abroad, and on the first day they would invite them to dinner, sending them on the next chickens, eggs, vegetables, fruits and other country produce. This is why artists called pictures representing things sent to guests xenia.

(Vitruvius, *The Ten Books on Architecture*, VI, 7, 4)

The *xenia* known to us now are Roman, not Greek, and unlikely to have literally represented 'things sent to guests', since this was not a Roman custom. Some even advertised ancient snack bars, where food was sold. The majority were rediscovered in and around the resorts of Pompeii and Herculaneum – either because more wall paintings were preserved there under the mud and ash of the catastrophic volcanic eruption of Mount Vesuvius in AD 79, or because pictures of wholesome 'country produce' were especially popular in the summer residences of Roman and Neapolitan magnates.

The walls of a room from a luxurious villa at Boscoreale near Pompeii, now re-erected in the Metropolitan Museum of Art in New York, were painted in the mid-first century BC as a series of vistas of the outside world, separated by columns. Some of these views represent ideal cityscapes, others gardens with artificial grottoes, fountains and arbours. Flanking the room's actual window – which might have looked out on just such a garden – the artist painted a fictitious low wall decorated with a

15

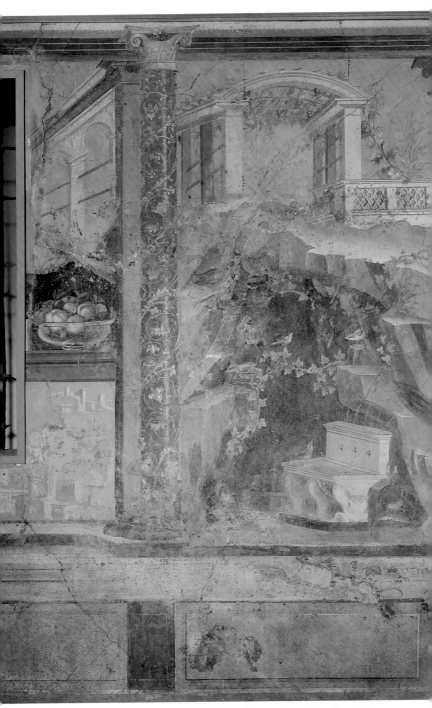

9. Bedroom of a villa at Boscoreale, near Pompeii, mid-first century BC wall paintings.
New York, The Metropolitan Museum of Art, Rogers Fund.

cityscape in tones of yellow and ochre, not in the many different colours of the 'real' view beyond. On this wall, as it were in front of that 'real' view, he set a glass bowl of peaches, plums and apples [9].

The vistas, inspired by stage scenery and painted from multiple viewpoints, seem obviously the products of artifice, but the still life appears quite real. The wealthy owner of this pleasant summer retreat could forever count on refreshing himself, and his guests, with fruits from his estate.

A century later, most of the *xenia* in private villas, though still painted directly on the plaster, were intended to look like small framed easel pictures hung in a picture gallery among other, larger mythological scenes and landscapes [10]. In these images, realistic details, such as the shadows cast on the wall by the dead thrushes and the towel, could not seriously have been intended to deceive the eye. These *xenia*, unlike the bowl of fruit in Figure 9, do not simply counterfeit objects which might really be present in the room. They are even wittier *jeux d'esprit*: still lifes that are part of fictitious collections of paintings in various genres.

Whatever their level of illusion, *xenia* in private villas celebrate the riches of the countryside and its rustic pleasures. They never represent human figures – neither the villas' owners, nor those who worked their land. In this respect they resemble the images of country produce painted in Flanders, many centuries later, for the picture galleries of a land-owning

10. *Still life* wall painting, from the Properties of Julia Felix, Pompeii, First century AD Naples, Museo Archeologico Nazionale.

17

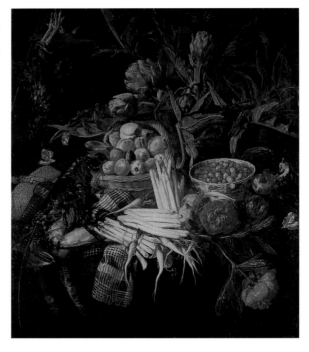

11. Pieter Snijers, *A Still Life with Fruit, Vegetables, Dead Chickens and a Lobster*, 1707–52. 118.8 x 99.7 cm.

aristocracy [11]. What really distinguishes the ancient *xenia* from these more lavish arrays, however, is not their spareness, but the fact that *xenia* always reproduce their limited range of motifs in the same way, with the same colours, highlights and shadows. The realism that appears so startling in one or two examples is revealed as craftsmanlike repetition of patterns taught and copied in the workshop, and rarely, if ever, checked against reality. What now survives from antiquity is the work of supremely well-trained interior decorators; the originals by great innovative artists have been lost.

The Greeks also invented another kind of painting of provisions and objects in daily use, which often included human figures as well as live animals, and flattered the wealthy in a different way.

Discussing Greek artists 'celebrated ... for minor pictures' (or perhaps 'smaller pictures'), the first-century AD Latin writer, Pliny the Elder, singles out Peiraikos, who gave the keenest delight, and acquired glory and riches, with humble 'barbers' shops and cobblers' stalls, asses, foodstuffs and the like, consequently receiving a Greek name meaning "painter of sordid subjects" ' [*rhyparographos*, or painter of filth].

18

Allowing for differences in style, medium, scale and social circumstances, Peiraikos's long-vanished filthy pictures may have resembled (and probably inspired) the paintings of 'dishonourable' occupations reinvented by sixteenth-century Netherlandish artists, such as Marinus's repellent tax collectors [12], or the encyclopaedic market and kitchen scenes of Pieter Aertsen and his nephew Joachim Beuckelaer [13]. Their hyper-realistic still-life details simultaneously attract the viewer's attention and expose the turpitude of the human figures. The coins, ledgers

12. Marinus van Reymerswaele, *Two Tax Gatherers*, probably about 1540. 92 x 74.6 cm.

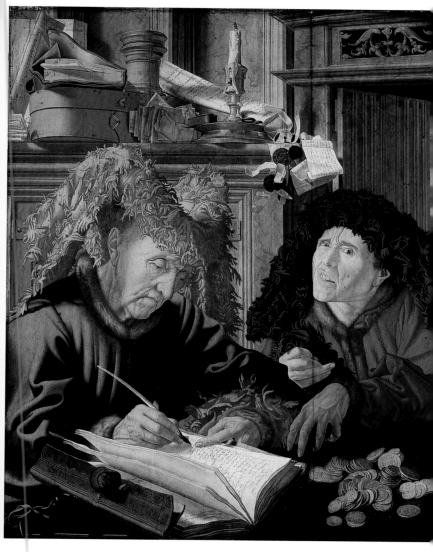

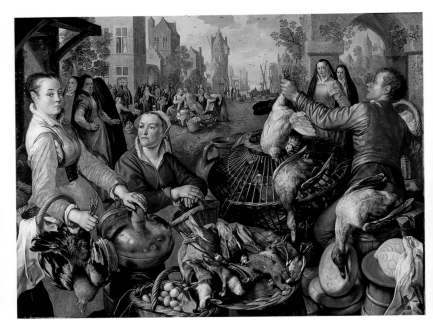

13. Joachim
Beuckelaer,
*The Four
Elements: Air.
A Poultry
Market with the
Prodigal Son in the
background*,
1570.
157.3 x 215 cm.

and documents in Marinus's picture [12] readily
reveal the boundless greed and officiousness of a uni-
versally despised profession. For today's viewer, the
significance of Beuckelaer's larger and more complex
*A Poultry Market, with the Prodigal Son in the back-
ground* [13, 14 and 15] is less obvious.

The picture is one of a set of four recently
acquired by the National Gallery, including also *A
Fruit and Vegetable Market, with the Flight into Egypt
in the background*; *A Kitchen Scene with Christ in the
House of Martha and Mary in the background*, and *A
Fish Market, with the Miraculous Draught of Fishes in
the background*. Each painting juxtaposes a biblical
scene in the background with one of lovingly chroni-
cled worldly abundance in the foreground. As a series
of four, they could have represented the seasons, but
in fact Beuckelaer alludes to the four elements of
ancient cosmology: earth (source of the greengrocer's
produce), air (through which the poulterer's birds
can fly), fire (used for cooking in the kitchen) and
water (the fishes' realm). These four elements were
thought to be linked, through the influence of the
planets, to the four temperaments of human nature,
determined by an imbalance of the four bodily fluids
or 'humours': black bile or *melancholia*, blood, choler
and phlegm. I can find little evidence of melancholic,

20

choleric or phlegmatic characters in the other three paintings, but the ruddy poultry boy on the right, and the showy young woman on the left of *A Poultry Market* seem to be of the *sanguine* disposition (from the Latin *sanguis*, 'blood') associated with air. Resting her left hand on a conspicuous water jar [14], the girl further demonstrates the 'hot-wet' temperament governed by the planet Venus – astrological descendant of the ancient pagan deity of love, born of the sea, and as treacherous.

14. Detail of 13.

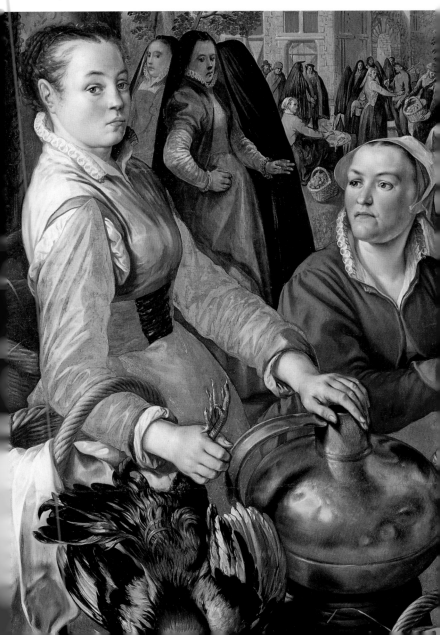

The boy brandishes a hen for sale, and in her right hand the girl holds a struggling cock. The Dutch word for bird closely resembles the slang term for copulation, *vogelen*. Poultry is not the only commodity traded at this stall. The sexual innuendo is made explicit in the background vignette of the Prodigal Son [15]: the debauched youth waves a goose by the neck, and canoodles with women in the market square, rather than indoors in the more usual brothel setting. The Bible tells us that he will repent and find forgiveness – but can the hot-blooded girl and boy, in a modern city heedless of God, transcend their elemental inclinations?

Beuckelaer's picture, apparently describing and codifying the bounty and variety of Nature, also illustrates vulgar sensuality. If *xenia* celebrated patrons' wealth and their tasteful preference for simple, natural country fare, *rhyparography*, ancient and modern, pagan or Christian, ridiculed the depravity of their social inferiors. Needless to say, both kinds of pictures were produced only for those who could afford them. And both were seen as lacking the moral grandeur of images of the gods, of the mythical deeds of heroes or of portraits of the great.

The Middle Ages

One of the incidental consequences of the destruction of the Roman Empire in the fifth century, and the subsequent supremacy of the Christian Church in the political and cultural life of Europe, was the virtual demise of optically realistic art – and of still life as an independent genre (but see page 67).

The early medieval Church was more concerned with transmitting spiritual truths than with depicting outward appearances. But if flowers or foodstuffs were no longer painted for their own sake, such motifs survived, as we have seen, as symbols reinforcing the significance of religious images [5, 6].

Gradually, it became clear that the end of the world was not as imminent as a traumatised population had feared and hoped. Monastic seclusion, devoted to prayer, no longer seemed the only sure means of salvation. New religious orders were founded, dedicated to preaching Christian virtues to men and women who worked for a living, owned property, married and begat children. Scholarship and the arts both came down to earth to study and describe, with grateful wonder and growing precision, the marvels of God's creation and God-given human achievements.

By the fifteenth century, optical realism, if harnessed to aid devotion, had once more become an admissible aim of painting. In this tiny picture designed for private meditation and prayer [16–18], the lighted candle may signify a marriage candle, for Mary is both the Mother and the Bride of Christ. But not all the still-life accessories are symbolic. Some merely furnish the warm and well-appointed room, high above the city, in which the Virgin devotes herself to the care of her infant Son. She has just bathed him in front of the sparking fire, and gives him a cuddle before wrapping him up again in freshly laundered swaddling bands from the wicker basket at her feet. He returns her caresses, and plays with his genitals like any baby boy. Neither wet nurse nor nursemaid intrudes on this idyll of reciprocated love. This Mother and Child are not only objects of veneration: they show us what we should feel and how we ought to behave.

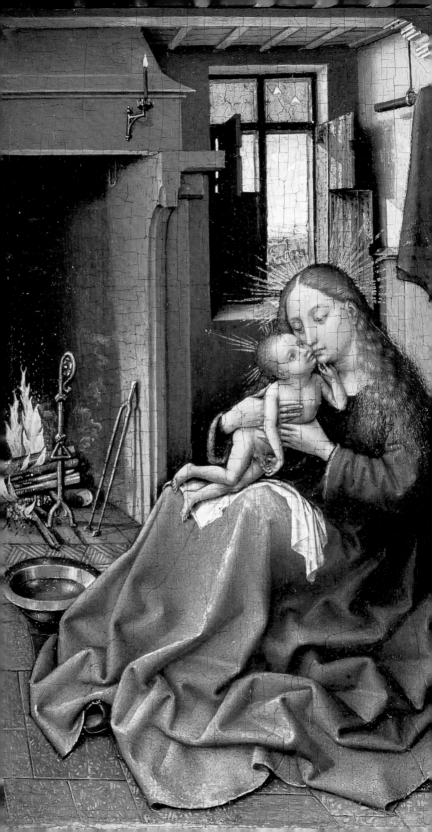

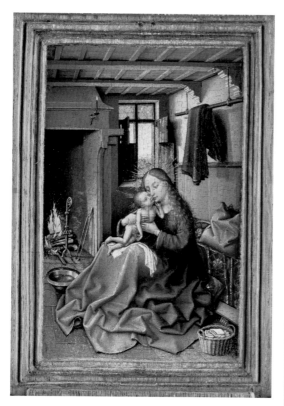

17. Workshop of Robert Campin (Jacques Daret?), *The Virgin and Child in an Interior*, about 1435.
22.5 x 15.4 cm.

16. (opposite) and 18, details of 17.

The artist, an early Netherlandish precursor of the representational tradition of Willem van Mieris [7], seems able to reproduce everything that the human eye can see: from velvet to tapestry to a water-filled brass basin, from a window's broken glass panes to the play of light on ceiling and wall, to fire tongs whose shadow bends at the right angle where the hearth meets the fireplace wall. Only the figures seem conventional, despite their lively attitudes. These ideal beings had never been observed in reality. It would be some time before real people were used as models for images of Christ or the Virgin, and even then most artists adjusted their appearance to accord with preconceived notions of beauty and decorum – whether inherited from Gothic art, as here, or, as in Figure 2, from ancient sculpture. Cushions, baskets or fire tongs did not need to be idealised in this way.

19. Quiringh van Brekelenkam, *Interior of a Tailor's Shop*, about 1655–61. 42.7 x 50 cm.

By 1600, the revival of classical learning, and the translation of Greek and Latin texts into modern languages, had acquainted both patrons and artists with accounts of *xenia* and *rhyparography*. In the heady knowledge that their representational skills rivalled, or even surpassed, those of the ancients, painters were eager to try their hand at genres so celebrated for descriptive accuracy. They were also keen to enlarge their share of the art market by introducing new, and eminently collectable, kinds of pictures. But such works were inherently problematic as well as rewarding.

First, and most importantly, while the ancients had appreciated paintings that imitated the appearance of everyday objects and scenes, they had set a higher moral and intellectual value on images of gods and heroes, and their exemplary deeds (page 22). The former seemed to require little imagination, and catered mainly to rich people's love of luxury. Idealising imagery was designed to have nobler ends. Like drama and epic poetry, it moved and inspired

viewers. Classical texts, in other words, both validated still-life painting and reinforced the traditional Christian suspicions of a mainly imitative art.

Painters struggling to shed the scorned status of manual craftsmen, and to be recognised as learned members of a liberal profession, had no wish to be identified as mere providers of luxuries or 'apes of nature'. Following the pioneering example of Marinus [12], Aertsen and Beuckelaer [13], they found various means of painting their cake and having it too: treating modern versions of the ancient genres so that even they might elevate the minds and morals of viewers.

Secondly, as demand for such images grew among all sections of society, especially in the newly formed Dutch Republic, it became increasingly difficult to classify them as either *xenia* or *rhyparography*. Marinus had satirised vice to counsel virtue [12]. But everyday occupations treated at face value, as in Quiringh van Brekelenkam's *Interior of a Tailor's Shop* [19], could hardly be called 'sordid subjects' without insulting the artists' clients, who were likely to be the same kind of people as those shown in the paintings. Brekelenkam's respectable artisan's family already own a still life [20], which in turn depicts a modest Dutch meal rather than the produce of an opulent country estate.

27

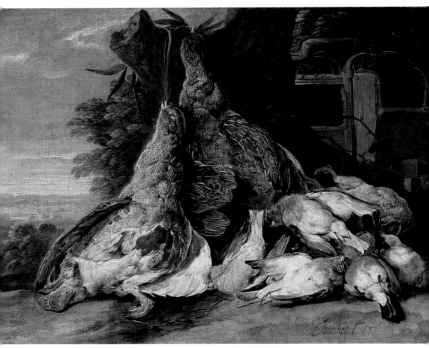

21. Jan Fyt, *Dead Birds in a Landscape*, probably 1640s. 41.6 x 56.8 cm.

22. Jan Fyt, *A Still Life with Fruit, Dead Game and a Parrot*, late 1640s. 84.7 x 113.4 cm.

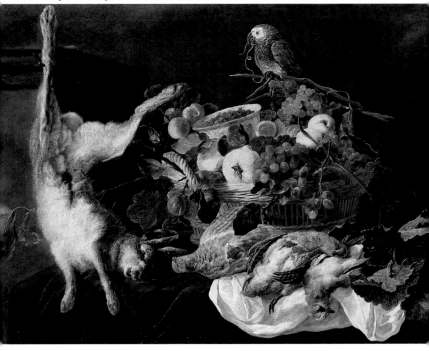

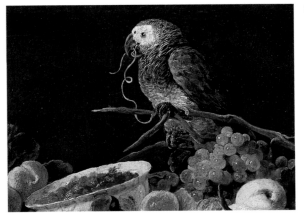

In the absence of satisfactory general terms, artists and viewers relied on descriptions of paintings' contents. Dutch inventories listed 'little banquets', 'little breakfasts', 'little tobaccos', 'little kitchens', 'flowerpots', 'fruit', 'game pieces' [21] and so on. As late as 1728, the sublime still-life specialist, Chardin, was enrolled in the French Royal Academy of Painting and Sculpture as 'a painter skilled in animals and fruit'.

Perhaps tired of hair-splitting, and recognising that all these works had something in common, the Dutch were the first to coin a general term for them, though not before about 1650: *stilleven*, the ancestor of the English *still life*, the German *Stilleben*, the much later French *nature morte* and Italian *natura morta* (literally, 'dead nature').

If *still* and *dead* seem to contradict *life* and *nature*, the paradox is more apparent than real. In all five languages, the livelier component of the term also implies 'a model', as in the English 'painted from the life', the French *après nature* and the Italian *del naturale*. The original intention of the coinage must have been to stress that these images were painted from the first-hand observation of inanimate objects.

A closer look reveals that the proposition cannot be taken literally. Live birds, insects, lizards, monkeys, cats, dogs, even people embellish many seventeenth-century still lifes, as they did ancient *xenia* and *rhyparography*. A quizzical parrot perches near the top of a composition of dead game and fruit attributed to Jan Fyt [22, 23]. The parrot, like the monkey, is a notorious mimic, and may be meant as a comment on

24. Detail of 25. Fyt's accomplished imitation of appearances. Jan van Os's *Fruit and Flowers in a Terracotta Vase* [25] boasts a dragonfly in the foreground [24].

This picture also includes a pineapple which, in reality, could never have cut such a dash atop a bouquet, since pineapples grow on short stout stems. Van Os's ebullient composition is no more a true record of reality than van Mieris's 'kitchen' scene [7].

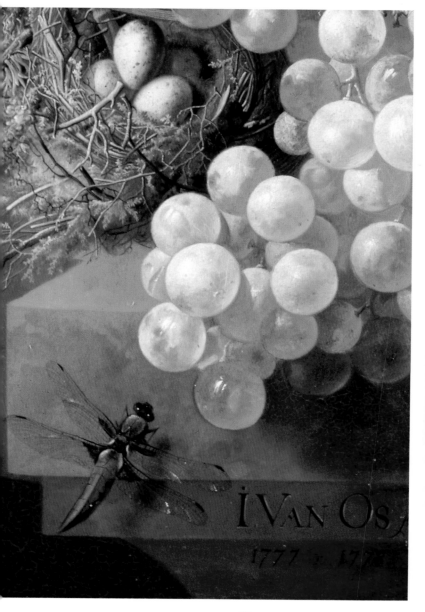

It was painted from the artist's imagination with the help of separate studies 'from the life' of its various components. These could only have been observed at different times of year: tulips in early spring, roses in early summer, hollyhocks and nasturtiums in high summer, grapes in the autumn.

The artifice is openly acknowledged in the two dates van Os inscribed below his signature on this picture: 1777 and 1778 [24].

25. Jan van Os, *Fruit and Flowers in a Terracotta Vase*, 1777–8. 89.1 x 71 cm.

26. Juan
Sánchez Cotán,
*Quince, Cabbage,
Melon and
Cucumber*,
around 1602.
69 x 84.5 cm.
San Diego
Museum of Art.
Gift of Anne R.
and Amy Putnam.

Surprisingly, a pioneer of more restrained still lifes, Juan Sánchez Cotán, had used the same method for his paintings of homely provisions hanging in the cool penumbra of Spanish larders [26]. Sánchez Cotán not only worked from separate studies but also repeated his own compositions. The identical fruit, vegetables and game fowl, dramatically spotlit and assembled in mathematically ordered patterns, appear in several pictures. Seen in isolation from the others, each version convinces the viewer that it was freshly painted from the life.

Modern 'still life' as revived or reinvented around 1600 was no more limited in its subject matter than ancient *xenia*, nor was it necessarily painted from the model. The implications of the new generic name were nonetheless justified. Inanimate objects are the focus of these pictures, and, until the twentieth century, direct observation played a part in the process of designing even the most fantastical bouquets and the most abstract geometries of cabbages and quinces.

Sánchez Cotán's studio inventory, drawn up in 1603, describes Figure 26 as 'A canvas on which there are a quince, a melon and a cabbage'. But long after 1650, Spaniards, alone in Western Europe, continued to shun the term *stilleven*. Seldom using its

Spanish translation, *naturaleza muerta*, they prefer to speak of *floreros*, 'flower pieces', and *bodegones*. A *bodegón* is not only a picture but also a cheap eating place, from *bodega*, a storeroom or wine cellar. *Bodegones*, originally limited to *rhyparography*-like scenes of taverns and kitchens, have also come to include all still lifes that are not *floreros*.

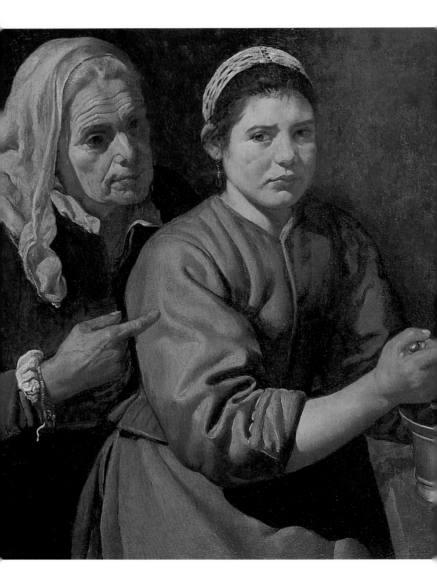

VELAZQUEZ

Although Sánchez Cotán's austere compositions more nearly conform to our notion of pure still life, I believe we can gain a better understanding of what makes the genre special from one of the *bodegones* painted around 1620 by a precocious genius: Velázquez's *Kitchen Scene with Christ in the House of Martha and Mary* [28].

From its English title, we might assume this to be a religious image, illustrating the episode in Luke's

34

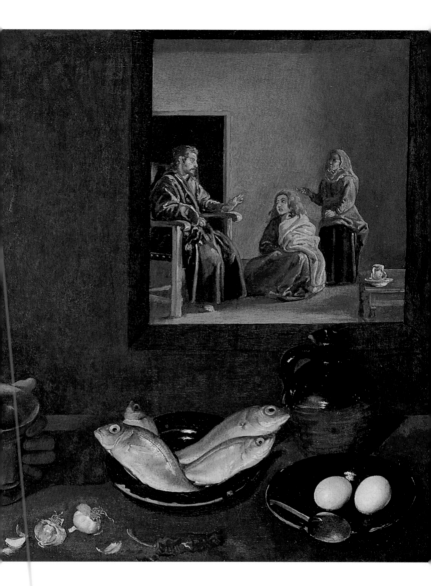

Gospel, 10:38–42, when Christ, a guest in Martha and Mary's house, reproves Martha for fretting about the meal while her sister Mary hears him preach. But the picture relegates Christ and his listeners to a small area in the background, seen through an aperture in the wall; the foreground is almost equally divided between two anonymous contemporary figures and a display of foodstuffs and kitchen ware. Although much sparer, and on a smaller scale, this

28. Diego Velázquez, *Kitchen Scene with Christ in the House of Martha and Mary*, probably 1618. 60 x 103.5 cm.

scheme recalls that of Beuckelaer's *Kitchen Scene with Christ in the House of Martha and Mary*, from the set of four pictures that includes *A Poultry Market* [13, pages 20–2], and it is generally accepted that Velázquez was inspired by engraved versions of Flemish paintings of this kind.

The significance of the older woman's admonition to the young cook is obscure, as is the precise relationship of the foreground to the sketchily painted biblical scene. Much has been written, though nothing concluded, about both.

What all viewers agree on is that this is a *bodegón* 'elevated' through association with a religious text. The picture's heart is on the kitchen table, with the brass mortar and pestle, the four shimmering sea bream on their earthenware plate, the half-glazed oil jug, another plate holding eggs and a pewter spoon, the chilli pepper and two heads of garlic, one already separated into cloves. Although the less perishable items appear repeatedly in Velázquez's *bodegones*, the consistent angles from which these studio props are lit and viewed suggest that the entire arrangement as we see it was painted from first-hand observation – and this is supported by contemporary accounts of the artist's methods.

Velázquez's teacher, father-in-law and first biographer, the learned and devout Francisco Pacheco, stoutly upheld the supremacy of ideal images. He nevertheless defended his pupil's works in a lower genre, dependent on the model:

Well, then, are bodegones not worthy of esteem? Of course they are, when they are painted as my son-in-law paints them, rising in this field so as to yield to no one; then they are worthy of the highest esteem. From these beginnings and in his portraits ... he hit upon the true imitation of nature, thereby stimulating the spirits of many artists with his powerful example. Thus, I myself ventured on one occasion, when I was in Madrid in 1625, to please a friend by painting him a small canvas with two figures from the life and flowers, fruit and other trifles ... And I was so successful that compared with this other works by my hand looked painted.
(*The Art of Painting*, Seville, 1649, Book III, chapter viii)

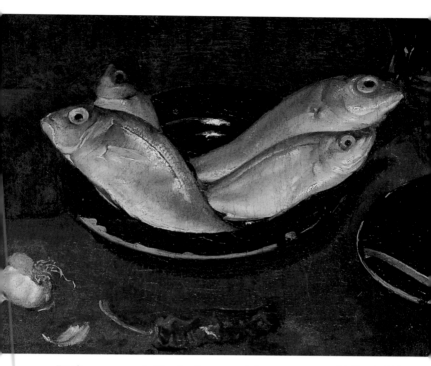

Pacheco uses platitudes borrowed from ancient authors to praise Velázquez's, and his own, *bodegones*: they are said to be a 'true imitation of nature', 'from the life' in contrast to works that 'looked painted'. This seems to contradict his own theoretical position, but he does not mean simply to commend slavish imitation of outward appearances. Velázquez's fish not only resemble bream: in death, they recall the sinuous motion of live fish swimming in the sea [29]. His eggs appear heavy [30], with thick and chalky shells like those of eggs newly laid by free-range country hens. You can almost hear the pestle ring against the mortar, and feel the dry crackle of the chilli pepper. He communicates to us his profound understanding of inner structures and processes, his imaginative empathy with things as they *are*.

Pacheco's platitudes highlight another, and the greatest, difficulty in writing about still life: to find words for the wordless. If I say that these fish and these eggs are more expressive than either of the two women, and infinitely more touching than the religious scene in the corner, will you know what I mean? Only, I think, if you look closely at the original picture. It is not just that the paint is more thickly and ener-

getically worked here, the textures more varied and truer to reality, the lights livelier, the shadows modified by reflections. Nor is it merely the interplay of abstract forms – the subtle pattern of repeated ovals, simultaneously flat and three-dimensional – nor the contrasts of yielding and hard, cool and warm, the harmony of whites, blacks, red and ochres. It is all this, and somehow much more. Rejecting the two extremes of aggrandisement or condescension, Velázquez tenderly re-presents to us a world we know intimately yet have been schooled to disparage. This is not the world of emotions and beliefs, of intellect, language, memory and action, but a world apprehended through our senses. Attention has been paid to things that cannot speak for themselves, that have no significance other than the one(s) we give them – and the painter's attentiveness moves us to meditate on them endlessly (though I think attempts to give Velázquez's provisions and utensils precise symbolic meanings are deeply misguided).

This is what I believe ultimately distinguishes still life from other categories of painting, and is at the root of its fascination. In essence, and at its best, the genre recaptures the pristine, universal experience of early infancy. It privileges being over doing, perception over interpretation; it attends to the wordless and makes it eloquent.

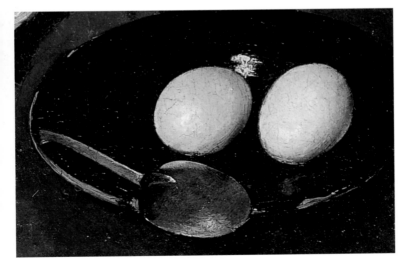

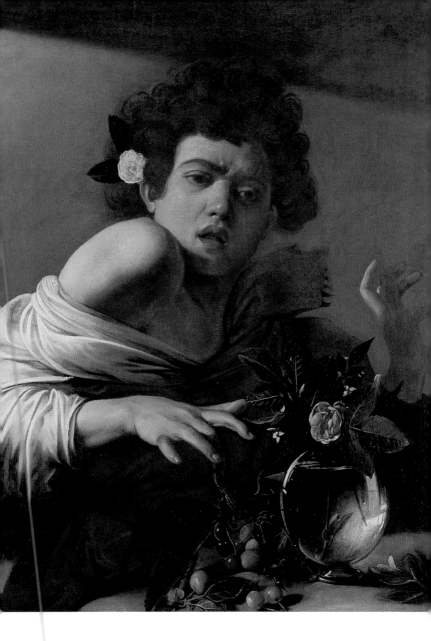

CARAVAGGIO

Velázquez's *bodegones* were inspired by sixteenth-century Flemish pictures of everyday scenes with religious insets [13; pages 20–2]. But he was almost certainly moved to paint them by the fame of a turbulent Italian artist, recently dead, whose works he could not have seen but whose reputation would have

31. Michelangelo Merisi da Caravaggio, *Boy bitten by a Lizard*, 1595–1600. 66 x 49.5 cm.

reached him via Naples, at that time under Spanish rule. Michelangelo Merisi, called Caravaggio from his father's native town in Lombardy, was praised, and often reviled, as an innovator who defied artistic conventions in order to paint directly and truthfully from life.

Caravaggio is sometimes said to have created 'the first modern still life': a lone basket of fruit on a shelf, dated around 1596 and now in Milan. More typical of the early works that gained him notoriety were pictures like the *Boy bitten by a Lizard* [31].

A lizard has been smuggled indoors with the fruit, and has nipped the hand of a boy reaching for a cherry. Now, as the shocked youth rears back, it tenaciously clings to his finger. The would-be biter has been bitten; anticipated pleasure turns to pain. The boy's cherry-ripe lips, his shirt provocatively lowered over one rounded shoulder, the rose behind his ear and the rose and jasmine in the glass vase all suggest that sweet fruit and fragrant flowers are being equated with the pleasures of sensuous love, the lizard with its dangers. Since images of a crayfish or lizard pinching someone's finger sometimes symbolise the sense of touch, the picture has also been interpreted as one of a series on the five senses, although there is no evidence that Caravaggio ever painted the other four.

Prominent though it is, the still life remains firmly secondary to the figure and his predicament, which direct our reading(s) of the whole picture. And these readings are predominantly influenced by literary texts. Whatever else they may signify, the flowers remind us that the boy's youth and beauty will fade as quickly as the short-lived rose, so often mourned by Renaissance poets. Only the painter's art endures, capturing the fleeting moment and arresting the cruel processes of time.

Along with wicker fruit baskets [34], glass flower vases became virtual hallmarks of Caravaggio's youthful works [32], and were much admired by contemporaries and early biographers:

. . . a carafe of flowers filled with water in which one can easily distinguish the reflections of a window and other objects in the room.

(Giovanni Baglione, 1642)

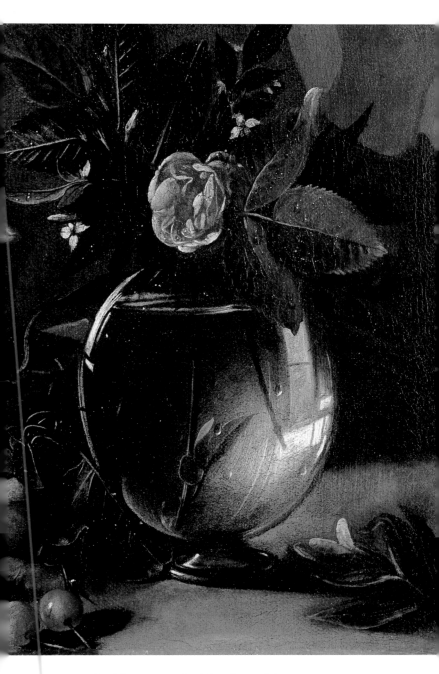

... a carafe of flowers in which he showed the transparency of the glass and of the water and in which one can see the reflection of a window in the room; the flowers are sprinkled with the freshest dew drops.

(Pietro Bellori, 1672)

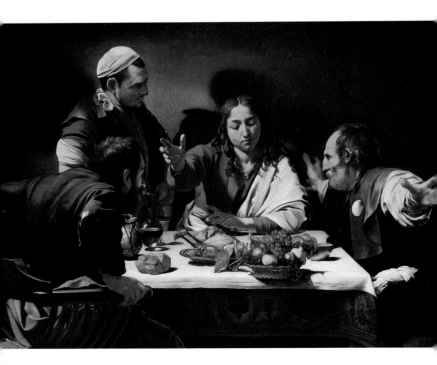

33. Michelangelo Merisi da Caravaggio, *The Supper at Emmaus*, 1601. 141 x 196.2 cm.

Caravaggio's biblical scene of the *Supper at Emmaus* [33], executed a few years later, includes a more complex and monumental still life. In contrast to Velázquez's [28], it heightens the drama of revelation enacted by the figures. Along with the shocked disciples, we are compelled to believe the evidence of our eyes, to recognise, in the plump-jowled, lank-haired guest across the table, Christ risen from his grave (Luke 24:31). He is as real and tangible as the bread he reaches out to bless, the water jug, the carafe of wine, the roast guinea fowl, the glazed bowl that reflects the snowy tablecloth, and the basket of fruit poised half-in and half-out of the picture [34]. Grapes, apples and pears have ripened at Eastertime; three days after his execution, a dead man returns to life and rejoins his friends at supper. By means of the 'true imitation of nature', Caravaggio makes us witness the miraculous suspension of nature's laws.

The artist is quoted as saying 'that it cost him as much effort to make a good painting of flowers as of figures'. I confess to a subjective prejudice. I marvel at Caravaggio's painting of still life, but it does not move me in the same way or as much as Velázquez's [28]. There is light but no air, passion but no tenderness,

in these harsh shadows and reflections, mottled fruit and tricky perspective; a sense of the painter's desire to astonish and impress. Velázquez, just as eager as Caravaggio to gain fame and riches, nonetheless seems to forget himself as his brush brings to life everything it touches. For me, his is the truer, if more enigmatic, miracle.

Neither of these great artists wished to be known as a specialist in pictures of fruit, flowers, and food-stuffs, however artfully 'elevated', and each moved on to 'higher' genres. Yet Caravaggio radically trans-formed religious painting by unsparingly making holy personages resemble his real-life models (compare the figures in 17, page 25). Velázquez, as Pacheco notes, achieved equal, if subtler and more introspective, real-ism in portraiture. As a result of their youthful training in still-life painting, both remained, in their different ways, devoted to the 'true imitation of nature'.

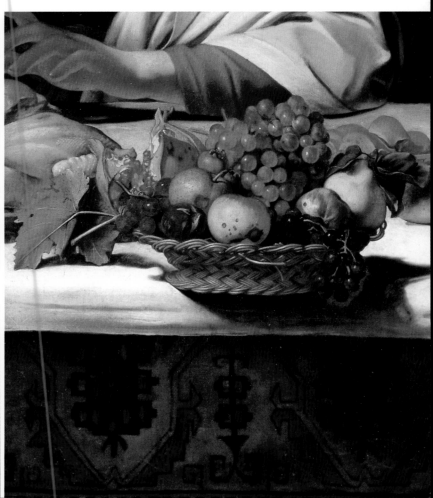

LOOKING
AT STILL LIFE

In our discussion of Velázquez, we arrived at a – somewhat metaphysical – definition of still life (page 38). But what are the genre's distinctive visual characteristics? What do pure still lifes *look* like?

The objects represented in a still life are the focus of the painter's attention and of our scrutiny; appearing in the foreground, seemingly or actually 'as large as life', they take up most of the surface of the painting. They are normally arrayed on a horizontal support like a table or shelf, with a wall, curtain or neutral colour behind them creating the illusion of 'shallow' space. Contrasts of colour and lighting between background and foreground may help to project objects 'forward' towards the spectator; Sánchez Cotán's larders, with their black backgrounds, are a classic example [26].

Still lifes may also be set in landscape [25]. Van Os uses paler colours, and less well-defined brushstrokes, in the landscape background, so that fruit and flowers appear as if silhouetted against a hazy, barely glimpsed vista of parkland.

Artists must not only decide on the *distance*, but also on the *height* from which objects are viewed. A relatively high point of view enables each individual item to be seen clearly, almost without overlapping, at the same time as permitting them to relate to each other in an overall pattern.

This point of view is perfectly consistent with the practicalities of painting in the studio. We can imagine Velázquez, having carefully positioned everything to his satisfaction on a wooden table, retiring without further ado to paint from his normal standing position at the easel [28]. Yet 'eye level' can also be used to suggest emotionally charged relations between the viewer and the viewed.

In painted portraits as in reality, we are sensitive to the level of the eyes in the human face. Someone who 'looks down' at us is felt to be supercilious; we ourselves feel superior to whoever 'looks up to us', while 'to look someone straight in the eye' is to demonstrate sincerity and a desire for intimacy.

Because inanimate objects don't as a rule have eyes, we forget that they do have an 'eye level' *vis-à-vis* the spectator, which can be raised or lowered with similarly expressive consequences.

Look carefully at Meléndez's *Still Life with Oranges and Walnuts* [35], starting with the foreground, at the bottom of the picture. Tantalisingly close, walnuts – some with their shells already breached – offer themselves to the hand; oblong wooden boxes of *membrillo*, quince paste, invite us to prise open their splintery lids and reach for the sweet within. Deeper inward, where the light begins to fail, objects loom taller, and – looking from the white scalloped curve of the plate, across the wooden lid of a round sweet box, to the cloth-covered mouths of the jugs – we note that our eyes, scarcely rising above the rim of the olive barrel, are level with the neck of the taller jug. Its contents – oil, wine, or water – can never be visible to us, even were the string untied and the cover removed. This haughty jug is looking down at us.

Having stimulated our sense of touch, and tempted our greed, the provisions crowding Meléndez's board withdraw from us, as they retreat into cool darkness away from the harsh Spanish sun.

35. Luis Meléndez, *Still Life with Oranges and Walnuts*, 1772. 61 x 81.3 cm.

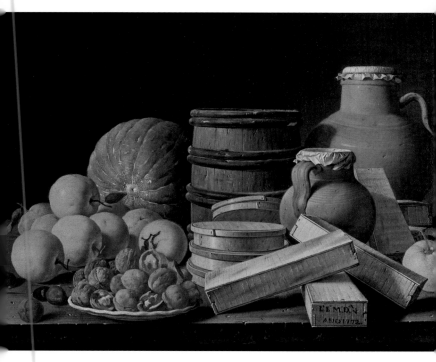

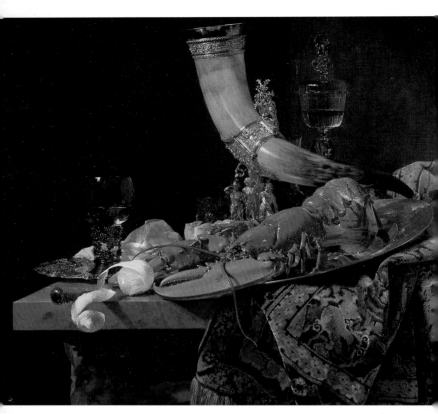

36. Willem Kalf,
*Still Life with the
Drinking-Horn
of the Saint
Sebastian Archers'
Guild, Lobster and
Glasses*,
about 1653.
86.4 x 102.2 cm.

37. Detail of 36.

Our response to Kalf's majestic *Still Life with the
Drinking-Horn of the Saint Sebastian Archers' Guild,
Lobster and Glasses* [36, 37], painted over a hundred
years earlier in Amsterdam, while not to the same
degree dependent on viewpoint, is enhanced when we
become aware of how this has been manipulated by
the artist.

In this picture we also look down at the table and
the objects nearest us, especially the slowly uncoiling
lemon peel; our eye level coincides with the bulbous
middle of the rummer – the large drinking glass –
above the lemon. But although he maintains the eye
level constant, Kalf suggests a dynamic instability of
multiple viewing points (as of a moving spectator) by
using the bunched folds of a multi-coloured oriental
rug to tilt the pewter or silver platter. On this slippery
slope, lustrous with scarlet reflections, the fiery
lobster takes on a menacing appearance. We view its
powerful claws from above; as its tail rises and curves,
we see it first in profile, then from beneath. Indubitably
cooked and immobile, the huge crustacean has

46

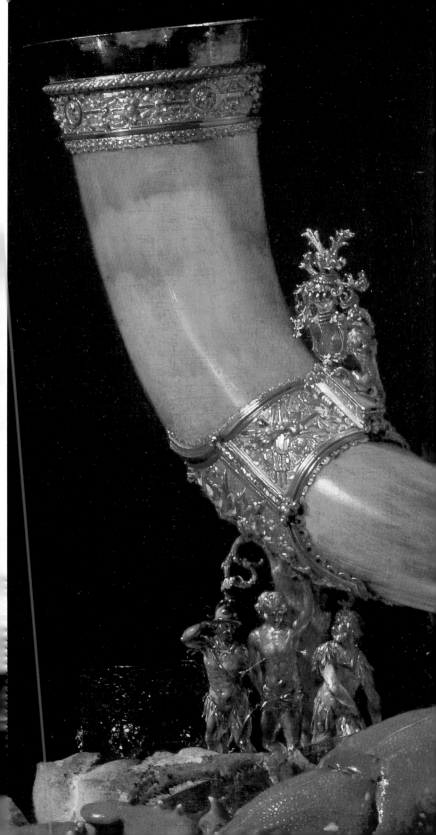

assumed the *contrapposto* – twists and turns around an axis – associated with living creatures.

The forceful red and yellow diagonal of lobster-and-lemon, sliding downward from right to left and from middle- to foreground, is counteracted by the upward curve of the silver-mounted buffalo drinking horn and the ornate vertical of the glass vessel behind it. The dark tip of the horn just touches the rim of the platter, as if to keep it from overbalancing and pitching lobster and lemon off the table into our space. Despite being more subdued in colour, and closer to the background, the horn assumes a commanding role in the composition, rising high above eye level nearly to the top of the painting and ending in a flourish of reflected lobster-red, viewed from below.

And that is as it should be. Contemporaries would have called this painting a *pronkstilleven*, a still life of display or ostentation. It is indeed a showcase of Holland's wealth: a lobster caught in native waters, Rhenish wine in handblown glass, a lemon imported from Spain or Sicily and a carpet from the Near East. But the Archers' Guild's drinking horn, with its elaborate mount representing the martyrdom of their patron Saint Sebastian, is more than a superb example of the silversmith's art. Still on display in Amsterdam's Historical Museum, the horn belonged to one of the militia companies that had won Dutch independence from Spanish tyranny. Although in Kalf's day these citizen militias were mainly active as sumptuous banqueting clubs, they remained notionally responsible for their country's safety and liberty. The painting, probably commissioned by a member of the Guild, can be viewed as an emblem of festive fellowship. But its main motif, the great horn upright as a sentinel, keeps ostentation, gluttony and drunkenness in check, and continues to embody a proud tradition of courage, self-sacrifice and vigilance.

This way of reading Kalf's picture seems all the more plausible when we compare it with another Dutch *pronkstilleven* of much the same date, similar size and content: Willem Claesz. Heda's *Still Life with a Lobster* [38, 39]. Heda depicts an even greater abundance of riches than Kalf: a silver-gilt goblet and goblet mount; Chinese porcelain dishes; a pigeon pie, with the bird's wing poised above the terrine; a plate of olives; a silver salt cellar. There is a knife, with its own

brass-mounted ebony scabbard. In place of Kalf's oriental carpet, white linen is draped over the table, its ample folds falling over the edge into the void. These vertical folds distract the eye from its higher vantage point, roughly at the level of the Roman warrior on the lid of the ornate metal goblet. As in Figure 36, this implication of movement has expressive consequences.

Where Kalf is heroic, Heda appears elegiac. The room in which the table has been set is lit by the window reflected in the rummer [39], yet it is plunged in darkness undispelled by the sparkle of glass and metalware, the dull green of olives, the yellow and red

38. Willem Claesz. Heda, *Still Life with a Lobster*, 1650–9. 114 x 103 cm.

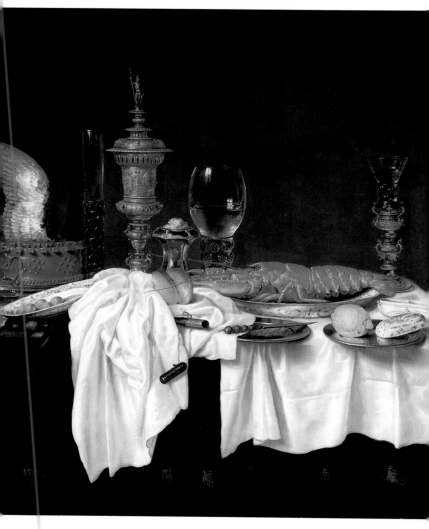

of lemon and lobster, the warm ochre of the bread roll. Kalf's composition threatens to spill out of the frame, but Heda's seems to recede within it, despite the outward thrust of the plates and knife in the foreground – as if the viewer, summoned to the feast, had been unaccountably called away. This viewer/diner – you or I – seems to have pushed his or her chair away, stood up, torn the napkin from under his or her chin, dropped it on the table, and after a last glance over the shoulder, vanished never to return. It is a strange and ghostly sensation.

There can, of course, be more mundane reasons for manipulating the spectator's viewpoint in a still life painting. Jan van Huysum's *Flowers in a Terracotta Vase* [40] seem to be set on a marble plinth in a shallow recess well above eye level. Almost certainly, like many flower pieces, the picture was designed to hang above a door or window; the angle at which the plinth

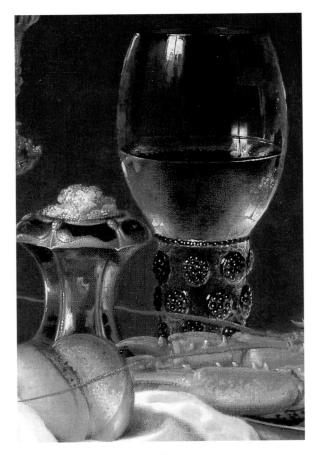

and vase are shown would then have coincided with the actual angle of vision of the spectator, furthering the illusion of reality (page 67). Yet, in contrast to these architectural elements, the flowers, fruit and bird's nest – painted, like van Os's [25], over two successive years – are not foreshortened. Larger than life, they present their most characteristic, undis-

40. Jan van Huysum, *Flowers in a Terracotta Vase,* 1736. 133.5 x 91.5 cm.

torted views, with every detail in sharp focus, as if defying the laws of optics in their eagerness to be recognised and admired even at a distance.

Van Huysum need not have thought explicitly of anything quite so fanciful. Having been told where his large painting would be located, he probably recorded the plinth and vase – which appear to be in one piece, though made of different materials – from direct observation, re-creating, or calculating, their steep foreshortening. The decorative terracotta relief is not foreshortened, and may have been painted from pre-existing drawings.

Turning then to separate studies of flowers, fruit, butterflies and nest, he arranged them in graceful profusion, spilling outward near the bottom of the picture to mask the inconsistencies of perspective. Only the nest is disturbing, as if glued upright to the vertical marble surface of the plinth.

We readily accept van Huysum's shifting points of view because we focus our attention on his translucent grapes, his velvety peach, the dew drops on his rose leaves and tulip petals – things most of us enjoy in life. (The unrealistic blue of the leaves is due to the fading over time of the yellow pigments that, together with blue, helped make up their original green colour.) Such motifs can be subjected to much greater artifice than van Huysum's before becoming unrecognisable or losing their appeal. No other genre wears its art on its sleeve more lightly than still life.

That is why, some hundred and fifty years later, it was to become a favoured vehicle for artistic experimentation. Of course, to innovate from within this popular genre was in itself a sign of rebellion against academic doctrine – which continued to regard still life as a purely imitative and decorative form, unworthy of intellectual or imaginative effort.

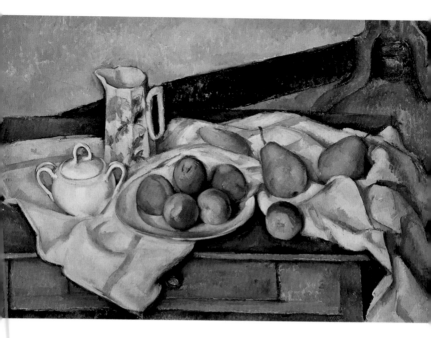

CEZANNE

There seems, today, nothing very rebellious in Cézanne's *Peaches and Pears*, now in Moscow [41, 42]. As meditative an artist as Velázquez, Cézanne spent hours and days arranging simple objects on a table to create the still lifes for which he became famous; the work of building up a composition to be painted from direct observation began long before he laid his first brush stroke on the canvas. His viewpoint in this picture is similar to Velázquez's [28], though much nearer; while Velázquez's still life simulates the ingredients of an actual meal about to be prepared, Cézanne's candidly proclaims its nature as a studio artefact. The white tablecloth is as artfully bunched as Heda's [38], and, like Heda, Kalf [36] or Meléndez [35], Cézanne deliberately concentrates the hot colours near the foreground.

Cézanne strove as hard as Velázquez to achieve the utmost truthfulness in his art, but he did not aim for a 'true imitation of nature'. Truthfulness, for him, meant above all making the viewer aware of the tension between three-dimensional reality and its representation on a flat surface. This tension is particularly apparent here.

41. Paul Cézanne, *Peaches and Pears*, 1888–90. 61 x 90 cm. Moscow, Pushkin State Museum.

42. Detail of 41.

Instead of projecting from a dark void, like Kalf's, Heda's or Meléndez's, Cézanne's laden table is set diagonally (albeit parallel to the surface of the painting) against a blue-grey wall with a black skirting. He adds a glimpse of floor and the bottom part of another table, of the type called *guéridon*, supported in the centre by a single leg with three splayed feet. All this should make the picture seem like a slice of reality that continues out of sight beyond the borders of the canvas.

Yet Cézanne simultaneously confounds our expectations of realistic spatial progression from

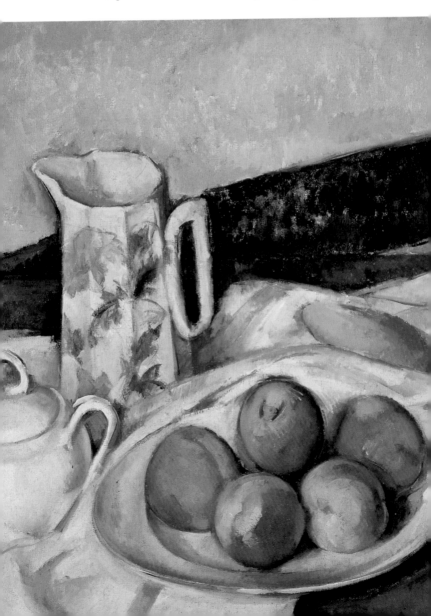

foreground to background and vice versa. The cool recessive blues, subdued greys, browns and blacks are not confined to the background, but reappear, applied more thickly, sometimes subtly altered to warmer, more advancing hues, in the modelling of the white linen and china, the shadows cast by the bold red, yellow and green fruit, in the wood of the table's front edge. The vertical plane of the wall, and the horizontal planes of the floor and tabletop are barely differentiated, and lines or shapes blithely disregard their supposed location in space. The contour

of the pear on the right 'rhymes' with the contour of the *guéridon's* left foot [42], prolonged in the light red stripe of the tablecloth, that runs parallel to the black skirting. This, in turn, takes a detour to model, and form a dark halo around, the milk jug. Line speaks to line, curve answers curve, spherical forms echo each other in a two-dimensional pattern at once restless and stable.

Assertive brushstrokes invite us to track the artist's movements across the surface as he works, sometimes in thin, at other times thick, paint, wet-in-wet, with brushes of different shapes and sizes, in stubby hatchings and dabs, or thin elegant strokes. He scrapes the paint in places to let the weave of the canvas show.

I've mentioned 'shadows', but in truth one can hardly speak of light in this picture. Colour seems inherent to the forms it describes; it glows, as it were, from within. And while we distinguish perfectly well peach from pear, china from cloth, their surfaces make no concession to our senses of touch or taste. It has been aptly said that they 'are independent of consumer values'. They are paint, yet also essential mass, true to itself.

To most contemporary viewers, and fellow-artists such as Fantin-Latour [1], Cézanne's still life would have looked brutal and brash – a rough sketch for a painting more than the painting itself. Now that snapshot photography, films and television have conditioned us to decipher ever more ambiguous images, Cézanne's asperities add to our enjoyment. We are increasingly mindful of his dogged sincerity, the ferocious dedication with which he reinterprets tradition.

A bolder challenge to the traditions of Western art was to come in the early twentieth century, when some artists decided to abandon completely the fiction that a painting is a window through which a stationary spectator sees three-dimensional objects located in three-dimensional space.

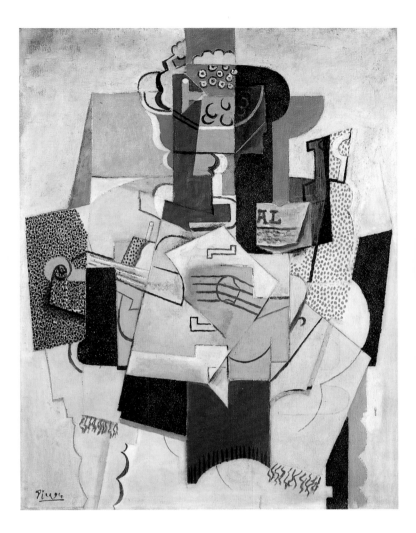

PICASSO

The objects in Picasso's *Fruit Dish, Bottle and Violin* [43, 44] are not set in any kind of space. There is neither foreground nor background, convexity nor concavity, in this picture, only the actual surface of the picture itself. No shadows lend the illusion of volume to individual objects – only the folded newspaper [JOURN]AL has a 'real' shadow – and nothing defines their texture as rough or smooth, lustrous or matt. Real differences of texture, independent of what is represented, are created where the canvas has been left bare, painted, or where sand has been glued to it.

Having decided not to reproduce appearances,

43. Pablo Picasso, *Fruit Dish, Bottle and Violin*, 1914. 92 x 73 cm.

Picasso concentrated on the 'basics' of painting: lines, shapes, colours and tones of light or dark. The lines are not confined to representing edges or shadows or decorative markings on objects, nor can we be sure what, if anything, is depicted by the shapes – not even whether an area is a 'shape' or a 'void'.

Colours and tones are as arbitrary as lines, shapes and textures. Nevertheless, relying on viewers' familiarity with the genre and its repertoire, the artist has chosen to evoke a still-life image. How else could his innovations be fully perceived and appreciated, except through comparison with established practice?

A curve on the right recalls the edge of a table, squiggles near the bottom the fringe of a tablecloth or napkin hanging down, and two series of descending curves, one dark grey and the other lighter, the profiles of table legs. Visibly shifting points of view are part of the novelty of this, as of all Cubist paintings. We seem to be looking down from above *into* a stemmed bowl of – possibly – apples and grapes, while at the same time we see its vertical stem unforeshortened, as if at eye level. Does the broken curve traced around the base mean we're seeing its (green) elevation and its (white) plane surface simultaneously? And what of the black and brick-coloured silhouettes to the right of the bowl? Could they be the same bowl in profile, from slightly different vantage points? How is the bottle shown – in profiled silhouette, or through the glass, or looking down into its mouth? Why is the newspaper so closely imitated? (In some Cubist paintings, a newspaper is re-presented by a real page of newsprint glued to the canvas.)

The violin has four strings, as a violin should, although some viewers have mistaken its flattened bridge for the sound hole of a guitar, and the strings themselves recall the staves of musical notation. The instrument fragments into a series of curves, angles and lines like the echo, memory or promise of music sounding through the air.

These are not questions to be answered, but to be enjoyed like a game of hide-and-seek. 'Pure' painting came first, to be interpreted later as a still life, with motifs surely never directly observed but playfully drawn from memory and the imagination. Yet the picture's relationship to the traditional genre is clearly suggested through minimal clues.

ELEVATING STILL LIFE

Metaphors, similes and attributes

Until the late nineteenth century, the mutely sensuous appeal of still life could not suffice to raise its lowly status; nor were still-life pictures as financially rewarding as those containing human figures. For just these reasons, even the great still-life specialist, Chardin (see page 29), was persuaded to diversify, and in the early 1730s began to paint small domestic scenes and portraits with still-life accessories [45].

To give the still-life genre a more elevated standing without, however, diluting its distinctive visual character, some seventeenth-century artists borrowed the tools of verbal discourse: figures of speech, to which ancient authors had given names still used in literary criticism, though rarely applied to the visual arts.

They mostly profited from the well-established tradition of translating into *visual* images the *verbal* images, or *metaphors*, of the Bible. This is what

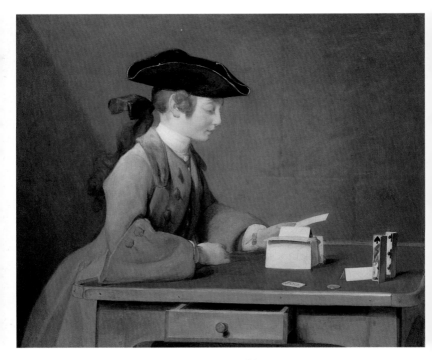

Francisco de Zurbarán, the leading religious painter in Seville, is almost certainly doing in his *Cup of Water and a Rose on a Silver Plate* [46].

46. Francisco de Zurbarán, *A Cup of Water and a Rose on a Silver Plate*, about 1630. 21.2 x 30.1 cm.

The Old Testament collection of marriage poems known as the *Song of Solomon* or *Song of Songs* is one of the richest sources of metaphors in the Bible. Christians believed that the poems celebrated the union of Christ and his Church, identified with the Virgin Mary. Metaphors for the Bride in the *Song of Songs* were thus understood to refer to Mary. 'I am the rose of Sharon' (Song of Solomon, 2:1), 'a fountain sealed' (4:12) and 'a well of living waters' (4:15) are among the most familiar.

Water in any form is also the most frequent emblem of purity. The identical cup of water on a silver plate is shown alongside the child Mary in Zurbarán's painting of the *Family of the Virgin* (Juan Abello Collection, Spain). A similar motif is offered to a royal princess in *Las Meninas* by Velázquez, Zurbarán's compatriot and contemporary (Prado, Madrid).

The Hebrew word 'rose' may in fact have referred to the autumn crocus, and the plant now called Rose of Sharon is a rock cistus, but in the European imagi-

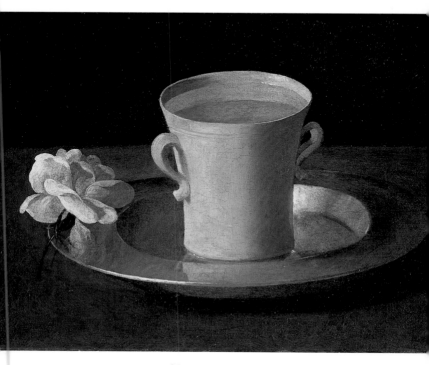

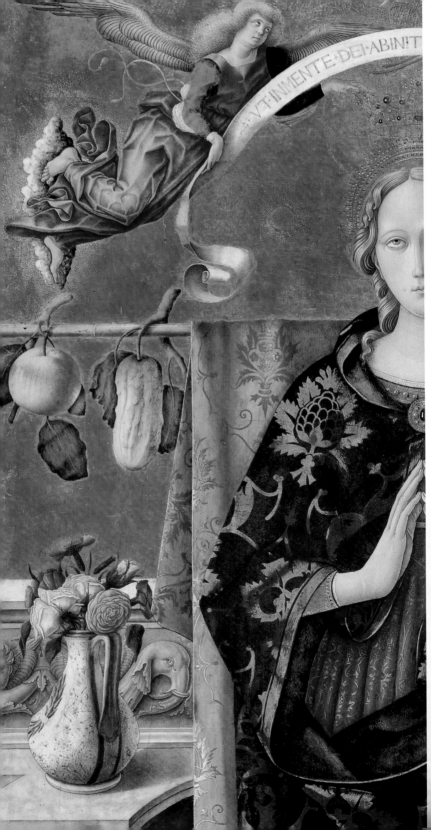

VT·INMENTE·DEI·ABIN·T

nation Mary has always been identified with a rose *rosa*, the 'mystic Rose' that blooms in the Garden of Paradise. Many pictures of the Virgin show her with vases of roses as well as of lilies; those by Crivelli are among the most beautiful [47].

In Figure 46, Zurbarán recorded at first hand a rose and a cup of water on a silver plate, and we may, if we wish, view the picture as nothing more than a study to be reused in various contexts. But as he produced very few secular paintings, it is likely that he always intended the image to direct our thoughts to the Virgin Mary, Rose of Sharon, fountain sealed and well of living waters. The little still life becomes both a metaphor of, and an offering to, the Queen of Heaven, the Beloved Bride of the *Song of Songs*.

This reading is reinforced by the reappearance of Figure 46, slightly altered, in the artist's *Still Life with Citrons, Oranges and a Rose* [48], which is also convincingly interpreted as a Marian image. The Latin word for citron was confused with the word for cedar, as in the scented 'cedars of Lebanon' of the *Song of Songs*. Orange trees bear flowers and fruit simultaneously, recalling the Virgin's miraculous fecundity. Solemnly arranged in a row at regular intervals, the symbolic objects guide our meditations like beads strung on a rosary.

47. Carlo Crivelli, *The Virgin and Child with Saints Francis and Sebastian*, 1491. 175.3 x 151.1 cm. Detail.

48. Francisco de Zurbarán, *Still Life with Citrons, Oranges and a Rose*, 1633. 62.23 x 109.54 cm. Pasadena, California, The Norton Simon Foundation.

'Vanitas'

49. Harmen
Steenwyck,
*Still Life:
An Allegory of the
Vanities of Human
Life*, about 1640.
39.2 x 50.7 cm.

If these still lifes by Zurbarán rely on metaphor, his older Dutch contemporary, Harmen Steenwyck, used a mixture of metaphor and *metonymy* – the figure of speech in which an attribute or accessory is substituted for a thing, activity or idea. The death's head in the foreground of his *Still Life: An Allegory of the Vanities of Human Life* [49] makes clear that this is no ordinary *pronkstilleven* or display of luxury objects; it warns us to 'read' the picture with mortality in mind. This kind of still life is known as a *vanitas*, from the doleful Latin opening of the Old Testament book of Ecclesiastes (or, The Preacher) 1:2, '*Vanitas vanitatum*',

Vanity of vanities, saith the Preacher ... all is vanity [futility].
I have seen all the works that are done under the sun; and, behold, all is vanity and vexation of spirit ... for there is no work, nor device, nor knowledge, nor wisdom, in the grave, whither thou goest.
(Ecclesiastes 1:2; 1:14; 9:10)

The calf- and morocco-bound volumes beside the skull stand for learning and knowledge; the Japanese sword, for military might – although, like the exotic

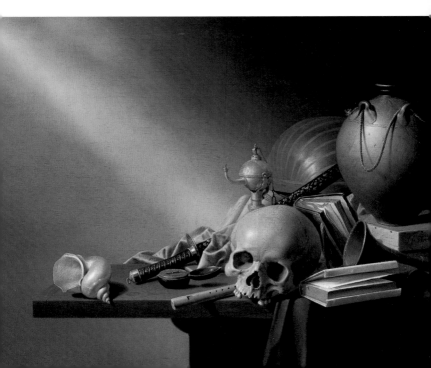

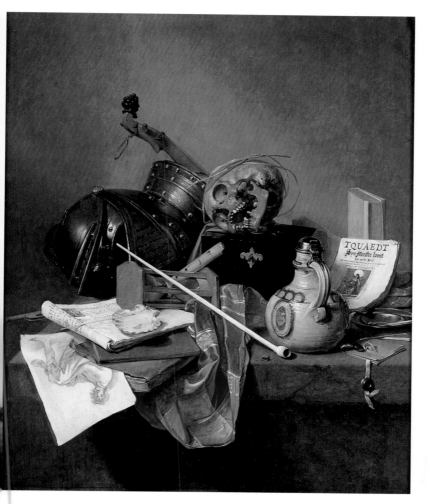

shell, it is also a costly collector's piece and thus an attribute of wealth. The chronometer measures the passing of time. Musical instruments – a recorder, a lute, part of a shawm (a medieval form of oboe) – and a stone liquor bottle signify the pleasures of the senses. The smoking oil lamp is a biblical metaphor for the brevity of human life: 'For my days are consumed like smoke . . . ' (Psalm 102: 3).

The vocabulary of *vanitas* still life can, like the words of any language, be used in any number of variations and combinations. A slightly later painting by Jan Jansz. Treck substitutes a Dutch clay pipe for Steenwyck's oil lamp, and an hour glass for the chronometer [50, 51]. A shell and straw, used by children to blow soap bubbles, illustrate *homo bulla*,

50. Jan Jansz.
Treck,
Vanitas Still Life,
1648.
90.5 x 78.4 cm.

51. Detail of 50.

'man the bubble', a classical metaphor for the fragility of human life. A silk shawl and a lacquer box stand for wealth, a chalk drawing for art, a violin and printed score for music. The title page of a popular drama serves as an apt caption: *Evil Pays its Master* [Evil is its own reward], *a comic play.* In a particularly macabre touch, Treck wreathes the skull with straw, mocking the evergreen laurels of fame [51].

Behind the long-dead hero's skull looms his helmet. Stretching the analogy with rhetoric almost to breaking point, we might view it as the embodiment of a third figure of speech, *synecdoche*, in which a part is made to represent the whole. Even the armour of chivalry is no defence against the scythe of the Grim Reaper, Death.

The contemporary Dutch owners of *vanitas* still lifes, readers of the Bible since childhood, could unashamedly enjoy these adroit imitations of outward appearances, while mindful of the Preacher's admonition,

Of making many books there is no end; and much study is a weariness of the flesh.

Let us hear the conclusion of the whole matter: Fear God, and keep his commandments: for this is the whole duty of man.

For God shall bring every work into judgment, with every secret thing, whether it be good, or whether it be evil. (Ecclesiastes 12:12–14)

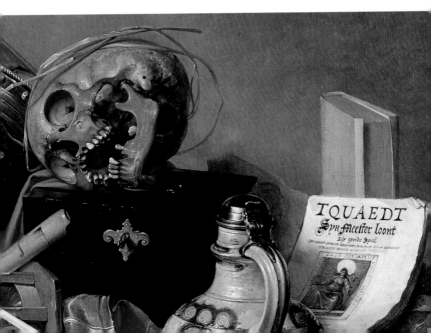

DECEIVING THE EYE:
'TROMPE L'OEIL'

In parts of Italy, a special kind of still life was developed as early as the fourteenth century, presumably as a result of the rediscovery of illusionistic ancient Roman *xenia* [9, 10].

The lower part of chapel walls, below eye level and beneath the religious images proper, was most liable to damage from people rubbing against it. For this reason it was normally decorated with repeat patterns imitating wall hangings, variegated marble or dressed stone. Now painters sometimes also added images of niches furnished with church vessels, like those used at the altar for Holy Communion. Even today, standing in the dark Florentine chapel, it is easy to mistake this picture [52] momentarily for an actual recess in the wall – which is why such painting is called *trompe l'oeil*. It deceives the eye by plausibly substituting an image for something that could really be there.

Trompe l'oeil decoration became highly prized in Renaissance Italy, especially when executed in costly

52. Taddeo Gaddi, *Trompe l'oeil* niche with eucharistic vessels, 1328–30. Florence, Baroncelli Chapel, Santa Croce.

53. Hans Holbein
the Younger,
*Jean de Dinteville
and Georges de
Selve ('The
Ambassadors'),*
1533.
207 x 209.5 cm.

wood-inlay, or *intarsia*. Around 1476, Duke Federico of Montefeltro had small private studies in his palaces at Gubbio and Urbino panelled in *intarsia*, an efficient as well as an ornamental way of insulating stone walls. The panelling concealed cupboards, whose contents, depicted in inlay on the doors, reflected the cultivated Duke's interests. Instruments for the study of astronomy, navigation and geometry, books, lutes and other musical instruments, pieces of armour, even a bowl of fruit, formed an array of still-life motifs resembling those in Holbein's portrait of two similarly accomplished French noblemen, *The Ambassadors* [53], painted some fifty years later.

Trompe l'oeil decoration spread rapidly from Italy to the rest of Europe. Van Huysum's *Flowers in a Terracotta Vase* [40] would have appeared in its original location as an architectural ornament made festive with fresh fruit and flowers.

In ancient Greece and Rome, flowers and fruit had been woven into wreaths and garlands, adorning the banquets of the rich, the temples of the gods and their sacrificial altars, which were consequently also often

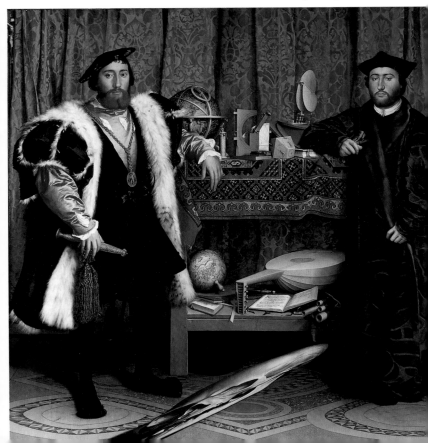

carved with never-fading stone garlands. Pliny
recounts the story of a poor flower girl, Glycera, who
supposedly invented garlands; her lover the painter
Pausias learned by imitating her 'to reproduce an
extremely numerous variety of flowers' (Pliny, *Natural
History*, XXXV, xl, 125).

Since Christians also garlanded statues, images,
and feast-day processional floats, it is not surprising
that Renaissance artists made *trompe l'oeil* versions.
Crivelli's *Vision of the Blessed Gabriele* is an especially
fine example [54]. Apples, pears and peaches are tied
together with ribbons and looped across the top of
the picture. They are not meant to be seen as within
the painting, since they appear to cast shadows
across it [55].

54. Carlo Crivelli,
*The Vision of the
Blessed Gabriele*,
probably about
1489.
141 x 87 cm.

Gabriele Ferretti, the superior of a Franciscan convent in Ancona, died in 1456. In 1489 the Pope allowed his body to be transferred to a sculpted tomb-altar in the convent church, where he could be venerated as an example of holiness, blessed in his lifetime with a miraculous vision of the Virgin and Child. Crivelli's altarpiece was commissioned to commemorate the miracle. But the garland, perhaps echoing the tomb's sculpted decoration, also records for posterity the celebrations that took place on the very day when Gabriele was first 'elevated to the glory of the altars'.

To deceive the eye successfully, a painting, like the niche in Figure 52 and Crivelli's garland [54, 55], must coincide as far as possible with the reality it replaces, from whatever the spectator's angle of vision. For this reason, *trompe l'oeil*, even more than other still-life paintings, avoids the depiction of deep space, and represents objects on the scale of life against a background parallel to the painted surface.

A specialised form of *trompe l'oeil*, the 'rack picture', takes illusion even further. It depicts an early form of notice board: a surface on which small objects are suspended on hooks or nails, or tucked in behind tapes pinned at intervals to form a 'rack'.

Rack pictures, popular in seventeenth-century northern Europe and nineteenth-century America, also had celebrated antique precedents: a mosaic floor seemingly littered with the debris of a feast, and Parrhasios's now-lost painting of a curtain, which deceived a competing artist, Zeuxis, into asking for it to be drawn aside to reveal the picture beneath (Pliny, *Natural History*, XXXV, xxxvi, 65).

Taken to such extremes, *trompe l'oeil*, as the art historian Norman Bryson writes, 'pretends that objects have not been pre-arranged into a composition ... Things present themselves ... as unorganised by human attention, or as abandoned by human attention, or as endlessly awaiting it'.

Perhaps the most disquieting *trompe l'oeil* image of something 'abandoned by human attention' was made by one of the most prolific seventeenth-century painters of rack pictures, Cornelius Gijsbrechts. Everything you see in *The Reverse of a Framed Painting* [56] is a painted illusion: the wooden frame and stretchers, the blank canvas, the piece of paper loosely affixed with red sealing wax and inscribed with

an inventory number. The eye is totally deceived, but the 'picture' remains mute, like the one 'hidden' behind Parrhasios's curtain.

Trompe l'oeil is most completely successful when it repudiates the artist's capacity to make mute objects eloquent, by attending only to their most superficial and inexpressive outward aspect.

Let us draw back from the brink of this self-denying art, with a picture which employs the strategy of *trompe l'oeil* for diametrically opposed ends [58].

Eva Gonzalès was the pupil of a fashionable Parisian artist; in 1869, she came to study with Manet. A year later he exhibited this portrait, which shows her elegantly dressed, sitting at an easel like an embodiment of *La Peinture*, the Art of Painting. She is putting the finishing touches to a flower piece, already ornately framed and wreathed with a gauze scarf. Her eyes are turned away from her painting, observing a model invisible to us, though the work on her easel is an artificial-looking confection – a genteel ornament for a bourgeois drawing room.

Behind Eva's chair is a portfolio of drawings; a canvas lies curled up in a roll on the carpet.

In the foreground, casting its shadow on Eva's dress, lies a single peony fallen out of its vase [57]. Disregarded by *La Peinture*, it has been noticed by Manet, who brings it to our attention. Its tousled white petals are more dazzling than the white muslin

57. Detail of 58.

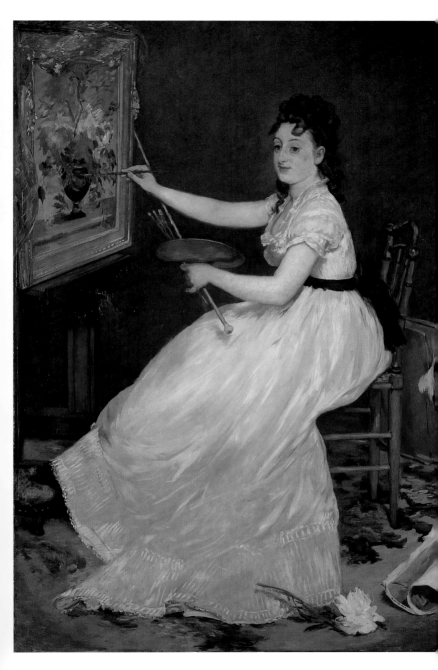

behind it. It is a peony in the bloom of life, unmindful of impending death. Now, thanks to Manet, it is a flower that will never fade.

To paraphrase Pacheco [page 36], 'compared with this ... other flowers look painted.'

58. Edouard Manet, *Eva Gonzalès*, 1870. 191.1 x 133.4 cm.

RE-PRESENTING
STILL LIFE

In the nineteenth century, still life, like Manet's peony, evaded both the strictures of moralists and the tired formulae of interior decorators. It became, as we have seen (pages 53–9), a vehicle for experimentation, which in itself raised its status among artists.

Although some of these experiments have more to do with the nature of painting than with the painting of Nature [43], still life remained wedded to the notion of truth to things that can best be apprehended through the senses: forms, colours, textures, the memory of flavours and fragrances. Culturally determined like all art forms, it is also one of the rare means by which art can give culture the slip, to engage as immediately with reality as is possible for human beings. When culture becomes especially oppressive, still life offers a means of escape.

In 1871, the progressive French painter Courbet found himself in prison, where he painted *Still Life with Apples and a Pomegranate* [59].

Courbet had been active in the liberal reforms of art and institutions under the Paris Commune, established after the defeat of France in the Franco-Prussian War and the collapse of the Second Empire. While doing his utmost to protect works of art in and around Paris, he advocated the dismantling of the Place Vendôme Column commemorating Napoleonic victories, as

a monument devoid of artistic value and tending by its character to perpetuate ideas of war and conquest ... for this reason in conflict with the spirit of modern civilisation and the universal fraternity and unity which should henceforth prevail among peoples.

Independently of the Arts Commission chaired by Courbet, the Column was not merely dismantled but demolished. When a right-wing government bloodily suppressed the Commune, Courbet was tried before a military court, and sentenced to a heavy fine and six months' imprisonment for his supposed part in the Column's destruction.

In the prison of Sainte-Pélagie, and in the clinic at Neuilly where he was admitted for treatment as a prisoner on parole, Courbet was brought fruit and flowers by friends and his sister Zoë. It was this that roused him to want to paint again. He was given brushes and a palette, but forbidden 'live models'.

One of the still lifes he painted in captivity and submitted to the Salon for exhibition in 1872 was contemptuously rejected by a jury of academicians. They declared themselves 'shocked by such senseless impudence'; the still life was caricatured with the caption, *Fruits of reflection.*

And so are these apples, quince and pomegranate, glowing darkly from prison cell or clinic room, fruits of reflection, though not of repentance. Massed on a rustic plate, with a glass of wine and a pewter jug beside them, they testify to Courbet's allegiance to the values of rural France, that fertile land his parents farmed, which he loved as much as he despised its political masters. He paints its fruit with the same rugged dignity he had previously conferred on its people and landscape [60].

But the work also affirms Courbet's devotion to the traditions of his art. He knows how to arrange the apples to make a picture, and where to stand to paint

it. His thickly laden brush defines contour, weight
and texture, the direction of the light and recession
into shadow. Over a thousand years of still-life paint-
ing had taught him the knack.

Labelled a 'Realist', Courbet responded:

The title 'realist' has been imposed on me . . .
Titles have never given the right idea of things; if they
did, works would be unnecessary . . .

I have studied the art of the ancients and
moderns without any dogmatic or preconceived
ideas. I have not tried to imitate the former or to copy
the latter, nor have I addressed myself to the point-
less objective of 'art for art's sake'. No – all I have
tried to do is to derive, from a complete knowledge of
tradition, a reasoned sense of my own independence
and individuality.

60. Detail of 59.

To achieve skill through knowledge – that has been my purpose. To record the manners, ideas and aspect of the age as I myself saw them – to be a man as well as a painter, in short to create living art – that is my aim.

With the memory of countless apples painted through the centuries helping him attend to the real apples in front of him, Courbet found freedom and dignity in captivity.

Recorded as he himself saw them, and re-presented to others as worthy of attention, respect and admiration, the fruit brought to vary a prison diet was transformed into still lifes, the living art of 'a man as well as a painter'.

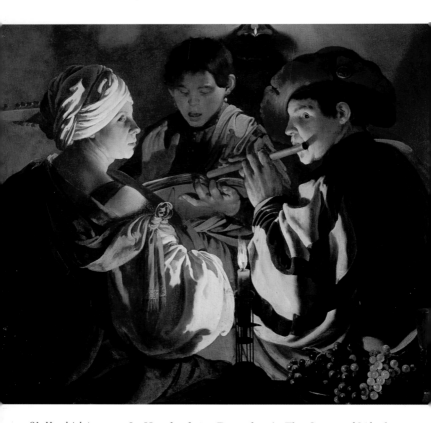

61. Hendrick ter
Brugghen,
The Concert,
about 1626.
99.1 x 116.8 cm.

In Hendrick ter Brugghen's *The Concert* [61], the
candles are burning low. Dawn draws near, the song
must end, and 'youth's a stuff will not endure'.

On the table between the revellers and the viewer is
a dish of grapes [62]. Before Parrhasios misled Zeuxis
with his painting of a curtain (page 70), Zeuxis had
exhibited grapes 'so true to nature' that birds had
come to peck at them (Pliny, *Natural History*, XXXV,
xxxvi, 65). Because he had deceived a fellow painter
and not mere birds, Parrhasios won that particular
contest – but ever since Pliny's account became avail-
able to artists (around 1600), it was Zeuxis most of
them tried to emulate. Besides being emblematic of
Bacchus, pagan god of wine and revels, of the fertility
of the land of Canaan at 'the time of the first ripe
grapes' (Numbers 13:20), and of the Eucharist of Holy
Communion, grapes became the supreme signifiers of
artists' ability to represent the natural world truthfully.

Looking at these grapes, I have often thought of
Pliny's story and its consequences, and also of E.H.
Gombrich's reminder that any still life is a *vanitas*,

because when we reach out to pluck the luscious fruit all we touch is cold paint. 62. Detail of 61.

But this is a double-edged reminder. As long as grapes are grown and enjoyed, any viewer (though perhaps not a bird) will be tempted to reach out to ter Brugghen's. Their unfading bloom almost convinces us that time can be made to stand still, that golden lads and girls need never turn to dust.

You don't have to know about *xenia* or Zeuxis, Caravaggio or Courbet, pagan or Christian symbolism to take pleasure in this enchantment, and to marvel at the art that made it possible.

A genre that has the potential to make you grateful to be alive can never be a mere reminder of futility, whatever judgement awaits.

FURTHER READING

Norman Bryson, *Looking at the Overlooked: four essays on still life painting*
Reaktion Books, London, 1990

E.H.Gombrich, 'Tradition and Expression in Western Still Life', *Meditations on a Hobby Horse and other Essays on the Theory of Art*,
London, Phaidon, 1963 (revised paperback 1994)

Francisco Pacheco, *Arte de la pintura*
Seville, Cátredra, 1649, ed. B. Bassegoda i Hugas, Madrid 1990
(There is not, as yet, an edition in English of this key text)

Pliny, *Natural History*, XXXV
Loeb Classical Library, Cambridge, Mass., Harvard University Press, 1961

Charles Sterling, *Still Life Painting: From Antiquity to the Twentieth Century*
New York, Harper & Row, 2nd rev. ed., 1981
(This title is now out of print but can be found in libraries)

Vitruvius, *The Ten Books on Architecture*
tr. M.H. Morgan, Cambridge, Mass., Harvard University Press, 1914 (paperback, Dover Publications, 1967)

PICTURE CREDITS